Copyright © 2016 Apparition Studios
All rights reserved.
ISBN: 1541124243
ISBN-13: 978-1541124240

Official Derby Coloring Book

By Jordan Colton

w/ contributions by Olivia Wild Child & Smackie O

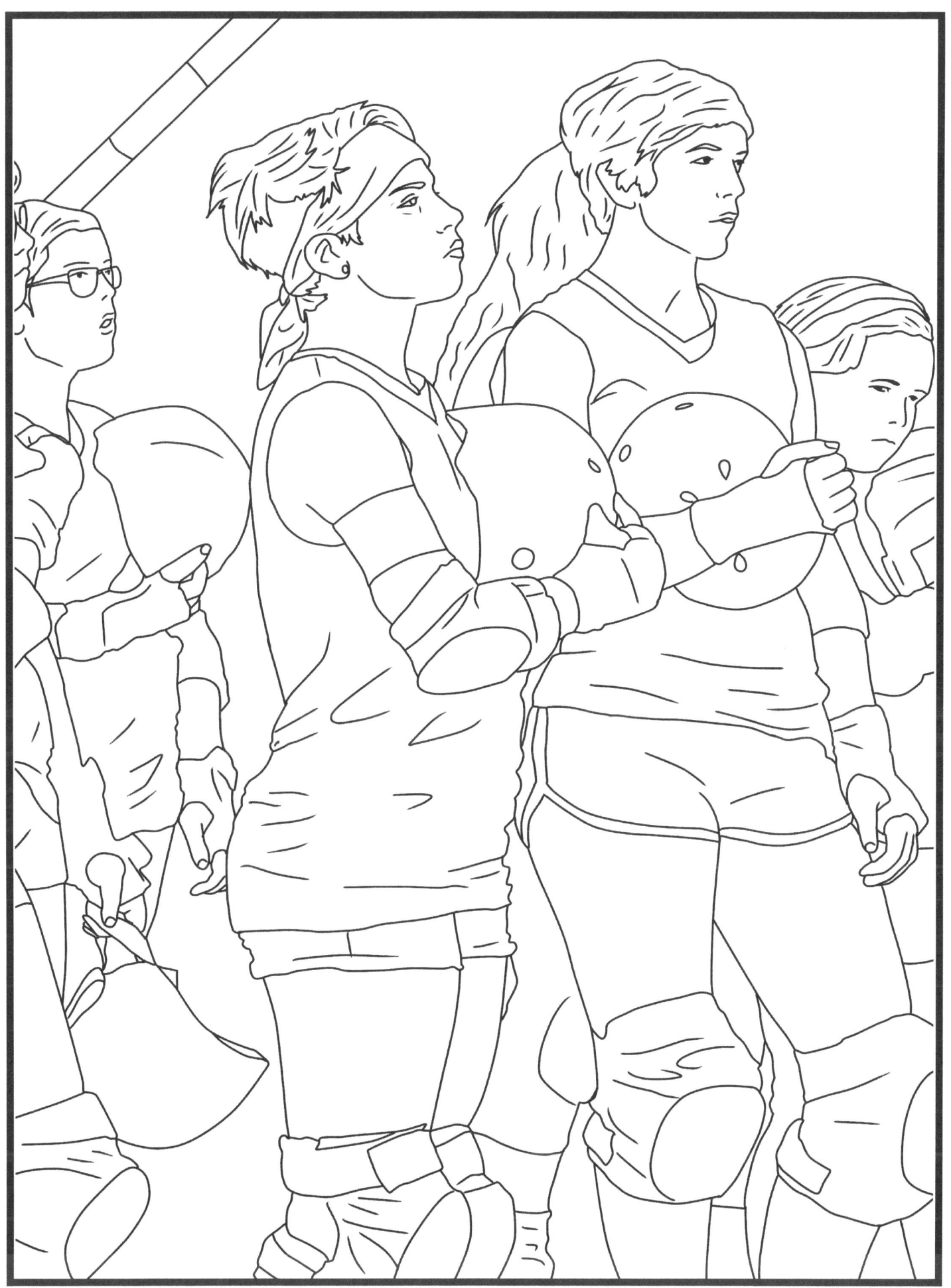

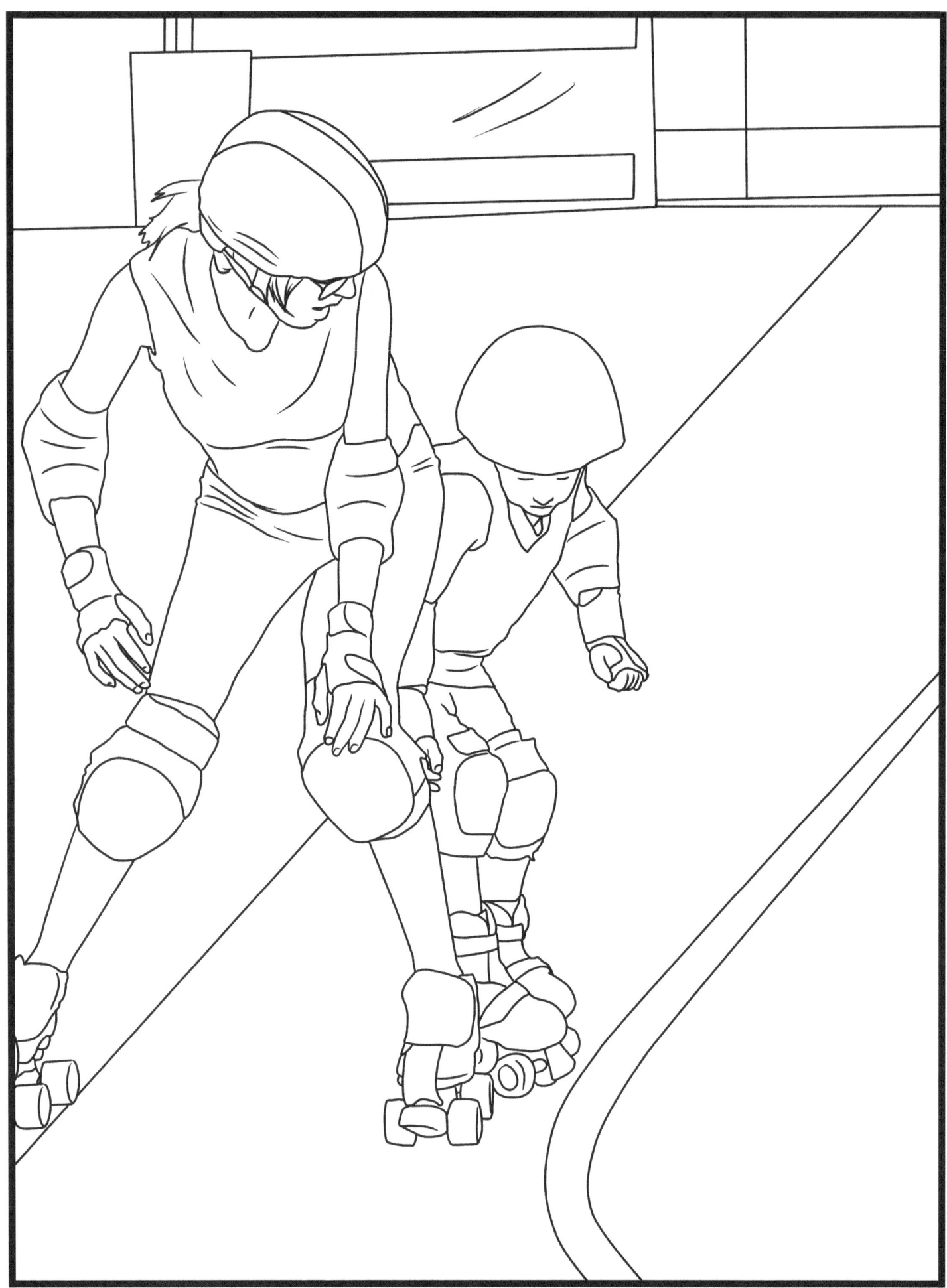

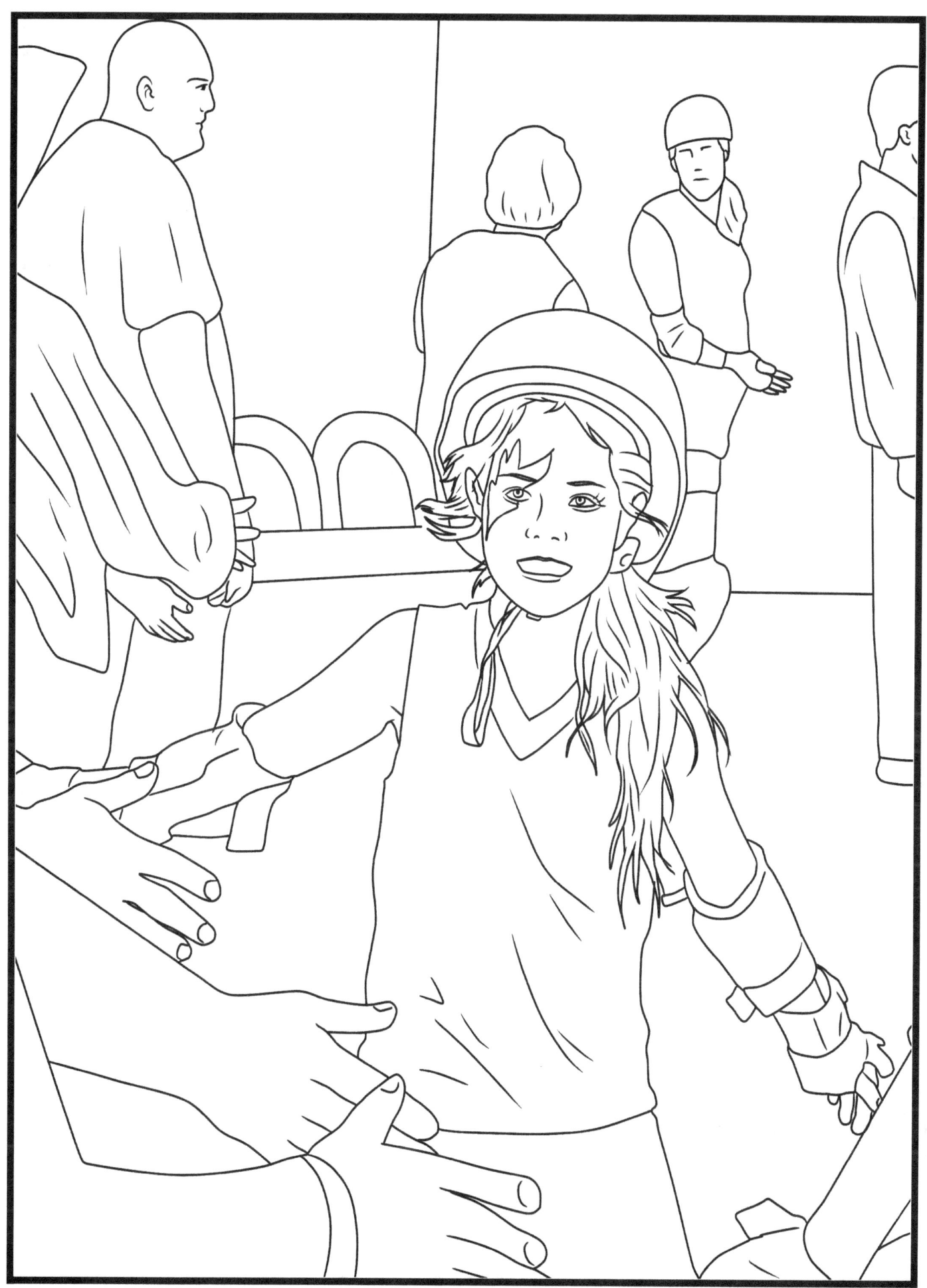

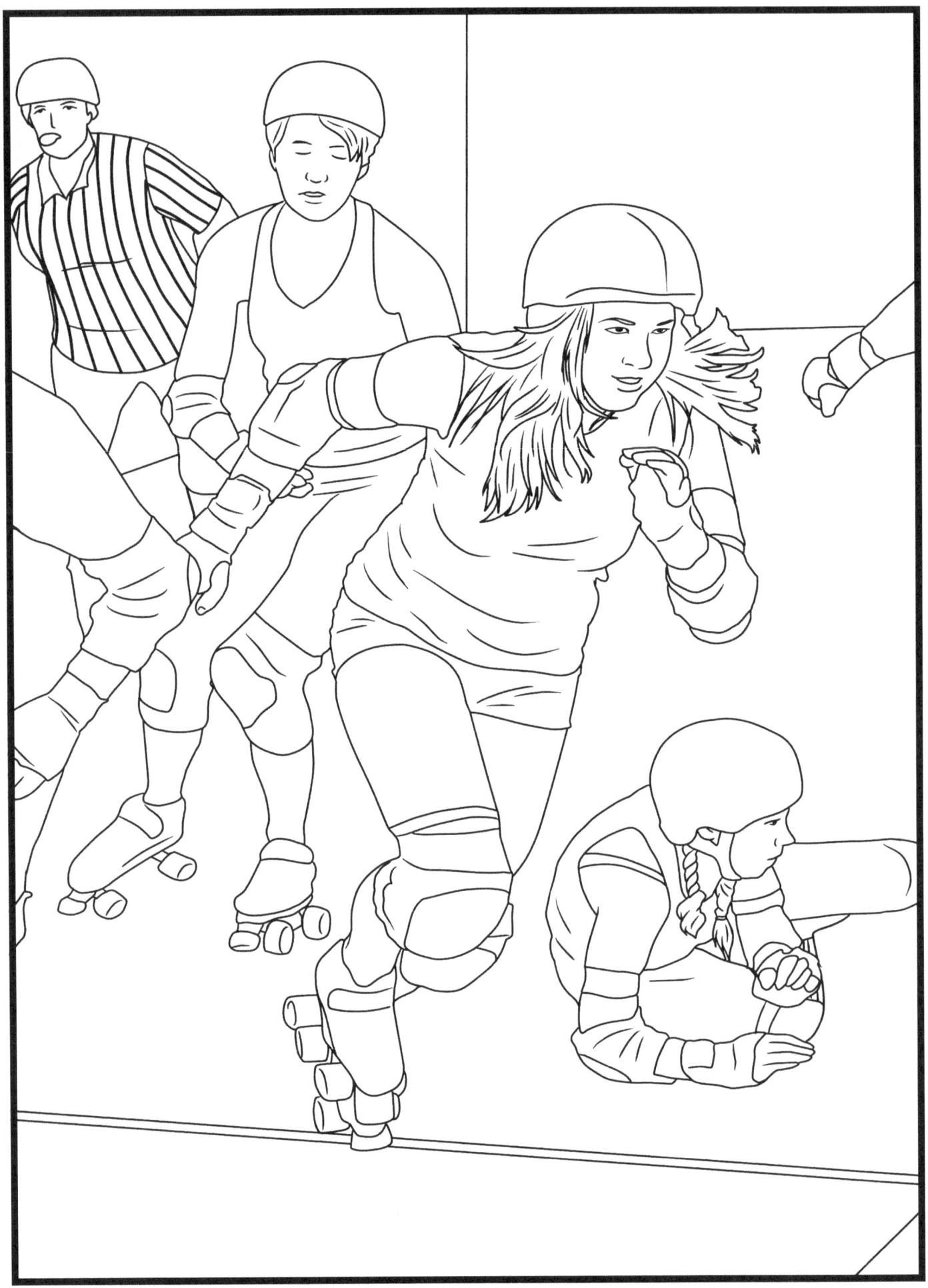

www.ingramcontent.com/pod-product-compliance
Lightning Source LLC
Chambersburg PA
CBHW081135180526
45170CB00008B/3117